TOULOUSE-LAUTREC
IN PARIS

© 2004 Assouline Publishing
601 West 26th Street, 18th floor
New York, NY 10001, USA
Tel.: 212 989-6810 Fax: 212 647-0005
www.assouline.com

Translated from the French by Molly Stevens and Alison Dundy, Translation and Art.

Color separation: Gravor (Switzerland)
Printed by *Partenaires-Livres*® (JL)

ISBN: 2 84323 655 X

TOULOUSE-LAUTREC IN PARIS

FRANCK MAUBERT

ASSOULINE

t he work, nothing but the work. That should be enough. But with Henri Toulouse-Lautrec, how can you leave aside the man, how can you not combine his life, his very existence, with his work as an artist? The two are inseparably intertwined. To dwell on his paintings, drawings, and lithographs—which are essential—and ignore his unique, colorful character would be a mistake, even if we know everything—or almost everything—about the painter's daily life and debauchery. The man is endearing and different, perhaps, from what has been passed on to us as legend. How can one resist the charm, humor, and slightly mad imagination of this fanatical libertine? And how can one resist his keen eye, which captured men (or women, rather) and their faults? To better understand the companion of the pages that follow, let us simply quote the great Jules Renard, a friend of Lautrec's, who brings him (back) to life better than anyone else: "Lautrec: a diminutive blacksmith wearing a pince-nez. A small bag with two compartments where he put his poor legs. Thick lips and hands like those he drew, with widespread bony fingers and thumbs like semicircles. [...] At first his small size makes a poor impression, then we're struck by his liveliness, his kindness, the grunt which separates his sentences and lifts his lips like the wind lifts the weather strip on a door."

Henri Toulouse-Lautrec. The combination of his life and work is, first of all, a slice of history that bears witness to Parisian life in a bygone Montmartre. Montmartre was then the haven for those living on the edge, and where they routinely dropped by for the local dance, the club scene, and the furious polkas. It was an enclosed world of dancers, pimps, so-called artists, penniless aristocrats and demimonde girls in satin frills. The Moulin Rouge, the Vélodrome, the Eldorado, Sarah Bernhardt, Yvette Guilbert, Jane Avril, La Goulue, Valentin le Désossé, Aristide Bruant: all the people and places that comprised the myth of Paris—this is the Lautrec of calendar art. Time and myth exaggerated the rest, as they did somewhat differently with Van Gogh, for example. These are artists whose legends surround their work, to the point of over-taking it with heresy and decadence. Their pictures have been seen so much, they've become so conventional, that our eyes tire of them. The same phenomenon occurs in music. How can one listen to Vivaldi's *Four Seasons* now that it's played on telephone answer-ing machines and in elevators? We have to rub our eyes and look at Lautrec's work as if for the first time, and move beyond the caricatures. This is certainly a difficult task, but one well worth the effort. Forget the folklore about Montmartre and the moral depravity of the brilliant dwarf, his drunken nights in the shadowy brothels and whorehouses with fiery women who called him "Monsieur Henri" and considered him one of the family. He is Henri Marie-Raymond Montfa, viscount of Toulouse-Lautrec, born an aristocrat and carrying the burden of his lineage: nearly a thousand years of the counts of Toulouse...

Henri de Toulouse-Lautrec was born on November 24, 1864, in the family estate Chateau du Bosc, whose terraced lands climbed to the ancient ramparts of Albi. As a newborn, he was nicknamed Little Jewel. Chateau du Bosc is also the place where one can admire the

largest Lautrec collection in the world: more than two hundred paintings and as many drawings. His family rode horses during the day and drew by the fireplace at night. He grew up with his mother Adèle's tales of knights in armor and crusades in the Holy Land. The embellished family history made the young Henri aware of his prestigious roots: those counts who, long ago, reigned over the regions of Languedoc, Rouergue, and Provence. The Toulouse-Lautrec family was particularly proud of having once defied the kings of France and even the popes. His father was a rather whimsical and eccentric count. It was a friend of the father's, René Princeteau—at that time a popular painter of horses and hunting scenes—who noticed young Henri's talent for drawing. (The two maintained a lifelong correspondence.) That's the pedigree.

h enri de Toulouse-Lautrec was ahead of his time: his outrageousness was entirely modern. Lautrec's spirit not only comes through every one of his paintings, but also animates his some 368 lithographs (more than half of which portray women, actresses, or prostitutes), zinc plate prints, and posters. These techniques were eminently modern for the period and allowed for a wide distribution of his work. His evocative line work and technique with color truly rejuvenated lithography. Thanks to him, posters became an integral part of pictorial art. One notices the degree to which the draftsman surpassed the painter, which is not to diminish the artist. When he painted, he continued to draw, and the graphic art dominated. Color for color's sake did not interest him, or at least not much. Nevertheless, he made an effort to enhance it to the level of his impeccable line work. But his

7

contemporaries considered him only a lithographer and illustrator. There is something of the sharpness of primitive art in Lautrec's work. It is not an accident that his tastes in painting led him to Paolo Uccello, Piero della Francesca, Lucas Cranach and Van Eyck. His classical leanings are only superficially apparent in his oil paintings. One wonders what artistic consciousness Lautrec had of himself. He was modest, even timid, with other artists. He was constantly developing his technique, but was this for innovation or to complete his work as rapidly as possible? The truth is, his speed and his dynamism did not really correspond to oil painting.

In fact, he didn't hesitate to use photography, the great invention of the nineteenth century. He used photographs for his compositions, to make changes, to sketch, and to "frame" his work. The word "instant" suited him perfectly, as he tried to precisely capture gestures and fleeting moments. He also appreciated photography as both a subject and a model, and complied with the wishes of his relatives—such as his cousin Marie Tapié de Celéyran, who was passionate about this new invention. For fun, he loved to pose like comical and unusual characters. "Play the fool," he'd say. Lautrec had been photographed since his first steps as a child, and he was always ready to ham it up for the camera. Years later, he became friends with the Montmartre photographer Sesceau (for whom he made a lithograph poster). But his closest photographer friend was Maurice Guibert. Lautrec performed the most incredible pranks for him, such as defecating on the Crotoy beach. This almost surrealist pose was before its time. Although he photographed Lautrec in the most improbable poses, Guibert was only an amateur; to earn a living, he represented the champagne company Moët & Chandon in brothels. Their journeys and adventures between 1896 and 1898 are recounted in the album *My Photographic Life*. The painter's sometimes grotesque follies concealed the artist's disabilities.

Lautrec put so much into these photographs, one wonders whether he did not consider himself to be the real author of them.

●

it was fashionable at the time, in the artistic and intellectual milieu, to denounce restrictive bourgeois values and decadence. Pessimism was de rigueur, and debauchery was one way of drowning out despair. As already mentioned, Lautrec was modest about his work. He compensated for this by trying to draw attention to himself in public. There were two roles in his repertoire: that of the declassed, epicurian, aristocratic snob (and a bit of a rascal); and that of the artist haunted by his own work. The word "decadence" dominated at the turn of the century, especially in Europe. This attitude was adopted by genuine dandies like Huysmans, Baudelaire, and Jarry, who made their lives permanent shows. In this vein, Lautrec would walk into a café with a cormorant named Tom on a leash, and offer the bird an absinthe. He invented strange and exotic cocktails of dubious colors for his friends; "short drinks" which his guests were required to swallow in one gulp. In his studio, he would tell his friends, "remember, we're here to drink," and ignore their advice about his work. His sense of theatrics, his love of costume (a trait inherited from his father, Alphonse, who also loved to dress up as a crusader, for example), his way of posing in the most extravagant and eccentric situations: everything shows Lautrec had understood that the meaning of posterity goes beyond exhibitionism. Isn't there a bit of Warhol about him? He poked fun at himself as well; he didn't hesitate to draw a self-parodying cartoon He would say, "Look at this posture, utterly lacking in elegance; this big rear end; this nose like a potato...isn't it beautiful?"

A congenital disease, achondroplasia, and a fragile bone structure stunted Lautrec's growth. In 1878, at the age of 14, he fractured his left femur in a bad fall. A year later, he broke the right femur in another fall. He remained permanently crippled and shorter than normal, measuring only about five feet tall. He began drawing when he was 9 years old and made his first painting when he was 15; it was of a rifleman saddling his horse. He retained a life-long interest in horses, a passion that ran in the family. His disability prevented him from riding, so he drew horses instead, and with real flair. He quickly established his own style: lively, light, flowing, and full of spirit. In his early years, he also painted portraits—of his mother and father, for example. His father, the remarkable Count Alphonse, loved to go hunting with hounds and rode his mare in the Bois de Boulogne. He wrote this advice in the dedication to a book on falconry that he gave to Henri in 1876: "Remember my boy, that life outdoors, and in broad daylight, is the only healthy kind. Everything deprived of liberty loses its very essence and quickly dies." Lautrec never took this advice, preferring the smoky, hot, sultry atmosphere of brothels and the teeming streets of Paris to his family birthplace and ancestral estates, parks, and vineyards—such as the Chateau du Bosc, in Albi, and the Chateau of Malromé, which belonged to his mother, Adèle. "He enjoyed life with the supreme freedom of a little boy in a public garden," said Tristan Bernard, who knew him well. His friend Maurice Joyant added, "His secret was to live freely and according to an inescapable law of nature, which led him to everything that was direct and simple." Throughout his life, he searched for his own humanity and strove to be with those who struck him as the most human, regardless of their class origins. This is why Lautrec excelled in portraiture. He wasn't only interested in "women of ill repute"; very early on, he had painted

the people around him in Albi and Bordeaux. These portraits are so lifelike that we can perceive the models' characters, their defects, their sicknesses, their age. The artist spared no one. Perhaps he avenged his own frailty by depicting the frailty of others. He painted in the way he lived: only interested in the essence of things and people.

h e was drawn to human beings who found liberation through dance, through alcohol, through sex: people who were uninhibited and completely at ease with their style and way of life, even if it were suicidal. Lautrec was ugly and had no aristocratic bearing. But among the lost souls and all those seated in godforsaken dives, he comported himself like a noble lord. The women, among whom he sought comfort, adored and pampered him, ignoring his deformity. His curiosity made him different and attractive. He was funny, cheerful, comical, and bursting with verve, life, and intelligence. He had the dignity not to speak of his own suffering, and was admired for that.

Lautrec's strange physique and public escapades quickly made him a legend in Paris nightlife, and these tales of debauchery pursue him more than a century later, as they remain tied to his work. The need to attract attention through eccentricity allowed him, a cripple, to not be forgotten, and made him seductive in ways other than physical. Yet he was also extremely distressed and anxious. His excesses and all manner of indulgences barely hid his existential angst. He once admitted, "I will burn out before I turn 40."

Lautrec only lived to be 37, devoured by alcoholism and syphilis. But he fully lived his thirty-seven years. "I've run out of ideas,"

he noted at the end of his life. And indeed, one wonders what changes might have shown in his work had he lived another decade or two. Explorer of the underworld, pleasure-seeker, historian, chronicler of illicit Parisian life, great witness to fin de siécle Paris, Lautrec is still a favorite with today's tourists. He is all these things at once, and more. As an artist, he was interested in movement, immediacy—life itself, and the gathering of humanity at dances, circuses, brothels. More than anything else, it was human nature in its social truth that Lautrec portrayed. In this instance, he is not an Impressionist. He despised landscape painting and was, in fact, an "anti-naturalist." He refused to compromise on this point with his friend Maurice Joyant, and when talking about Monet, Lautrec would say, "Only the figure exists. Landscape is and must only be incidental. The landscape painter is nothing but a brute. Landscape should have no purpose except to help us better understand the character of the figure. Corot, like the others, is successful only because of his figures…" He greatly admired Degas, from whom he borrowed the theme of women washing themselves: *Woman Combing Her Hair*, which Lautrec completed in 1891, is the title of a 1877 work by Degas. It was also through Degas that Lautrec discovered Far Eastern engraving, although he had already seen Utamaro's erotic prints when he painted the greenhouses and their courtesans. Lautrec painted with solvent on cardboard, and this lends the series— dedicated to the intimacy of women—its great fluidity, and the transparency of watercolor.

In 1882, he joined the Léon Bonnat studio, and soon after, Cormon's. Cormon was a well-respected official painter, nicknamed Father Patula, who specialized in Merovingian scenes painted with a soot palette. Lautrec did not make regular visits until 1887, although Cormon's studio soon became one of the cradles of

modern art. It was here that Lautrec met Van Gogh, Émile Bernard, and Louis Anquetin. Together they tried to set up group shows, like the one Van Gogh organized in a popular restaurant on Avenue de Clichy. It was a fiasco, but Van Gogh struck up a friendship with Lautrec—who loaned money to his Dutch friend, and in 1887 painted his portrait. If Lautrec always maintained his own style, one can nevertheless see that he borrowed Van Gogh's staccato touch and short brushstrokes. This "vibrato" changed his way of painting. The portraits drawn in 1890—both outdoor and interior scenes—certainly owe something to Van Gogh's choppy technique, although they are not as violent. In fact, Lautrec found his own style very early, a style that disregarded certain basic techniques ("tek-nik," he would say, separating the syllables), as if the rush allowed the artist to better capture the moment.

h is motto, "Ah! Life, life!" expresses this need for immediacy and also reveals a kind of hopeless optimism. Whether quickly sketching a clown in the Médrano circus or feverishly drawing a dancer, Lautrec searched for something beyond the posturings of his contemporaries; he looked for the human soul under the costumes and frills. He went to a deeper level with his models, a biting irony pierced through his thick eyeglasses, and his portraits are genuine confessions that uncover that "special something" in each subject. When he brings us into the intimacy of a bedroom or a brothel, he tries to make us understand that regardless of class background, the behavior and instincts of women are fundamentally the same. He was one of the rare painters of the period to confront the question of sex—one of

his favorite subjects—without sensationalizing it, and without vice or vulgarity. His characters are rendered naturally and animatedly; they evolve within a fluid spatial frame, without exactitude. This discovery, this "evasive space," which can be considered a means to drawing more rapidly, captures movement and introduces an element of true humanity. "Do what's real, not ideal," he repeated. That was the painter's great audacity, and what set him apart from most of his contemporaries, including Monet and Pissarro—not only in terms of technique but also in terms of the subject itself. The Impressionists only suggested figures, such as a silhouette in a landscape, or in Renoir's case, a sentimental mix of colors. In order to situate Lautrec in the history of painting, one must turn to artists such as Géricault, or even Daumier or Gavarnithe: the careful observers and sharp critics of bourgeois overconsumption in the nineteenth century.

1 autrec's strength lies in how he approached his subject. He was himself marginalized and spent his life, and his nights, with his "dolls," as Yvette Guilbert called them. If he associated with "girls of ill repute," it was because he identified with them socially, as he also felt rejected by society's morality and the public order. The painter became a reporter interested in the life of brothels, cafés, and clubs—the new locales for social integration. The most famous one, located at 6, Rue des Moulins, was where Lautrec painted many of his works, such as *Ladies at the Refectory, Visit to Rue des Moulins*, and *In the Lounge at Rue des Moulins*. In his *Elles* series, we see the women wandering about in bathrobes, washing themselves, putting on makeup, smoking, playing cards,

eating. Lautrec's tragic realism—embodied in *The Divan* (1894-1895), for example—depicts destitute, hardened women. Yet he lends them a classic grandeur, suggesting a world of enchantment. Lautrec strips things down and uncovers. There's a rawness to his painting, but nothing impure. No detail escapes the artist's notice; he spares nothing and no one. He emphasizes an expression, accentuates an attitude, even if, at times, he gives his subjects an imperial air. The girls might be terrible or ravishing, but in the end they all resemble one another, and more to the point, they all embody womanhood. Often, his familiarity, and his affection, would soften his touch and save them from vulgarity. If, at first, one notices mainly the purely formal and modeling qualities of these girls, a disguised sadness quickly comes out, through their listless gestures, their troubled looks, their bitter mouths. The brothels were the very image of fin de siécle decadence, and the realist writers were also drawn there: Zola and *Nana*, the Goncourt brothers and *La Fille Élisa*, Huysmans and *Marthe*, Maupassant and *La Maison Tellier*. Lautrec lived his era fully and captured the flavor of his times. It should indeed be noted that in 1890, Paris had approximately 60,000 prostitutes, and almost 14,000 painters!

The critics did not hesitate to attack Lautrec's wild behavior. According to them, he was a crazy, disabled alcoholic who could only produce bad paintings. However some more penetrating and respected writers like Octave Mirbeau did see Lautrec's strength. In 1891 Mirbeau praised the artist's "study of physiognomy and perception of character." In 1898, three years before his death, Lautrec's exhibit at London's Goupil Gallery received mixed, almost hostile reviews. Although the major newspapers recognized Lautrec as a great artist and noted his "brilliant technique," "marvelous skill," and "unusual combination of colors rendered with distinction," they all stigmatized his subjects as "abject." Selling his

artwork seemed contemptible to Lautrec, which pointed to his aristo-cratic origins. Nevertheless, he tried to participate in exhibitions. Théo van Gogh was the first dealer to take an interest in his work. Then came Maurice Joyant, who managed the Galerie Boussod, one of the international centers of contemporary painting. But Lautrec's work rarely sold. He had to wait until 1891 for the first public sale of his drawings to take place, and until 1898 for his paintings. One year after his death, the Galerie Durand-Ruel exhibited 105 of his paintings and 76 drawings; only two were sold. Between 1906 and 1913, the market price of his work notably increased, until the crash of 1929. It wasn't until 1952 that his work dramatically rose in value, when Lautrec was consecrated in John Huston's film *Moulin Rouge*. Fame caught up with Lautrec the artist.

his initial success came from his posters. As mentioned earlier, he introduced a new style and invented a language that was simultaneously advertisement and art. Lautrec was one of the artists who best captured his time: he made the first pictures of automobile drivers wearing enormous glasses; he was also the first to depict bicycle racers—who were soon to become the heroes of a new and very popular sport. His friend Tristan Bernard, director of two vlodromes, allowed him to remain on the side of tracks. Lautrec soon became acquainted with the world of racers, and even drew for new cycling brands such as Simpson, which produced chains, and Dunlop, which made rubber tires. In this respect, Lautrec was a modernist, an innovator, and perhaps, in his own way, the first great advertising executive. He also showed his talent in the numerous newspapers that flourished

at the time—such as *Le Mirliton* and *Le Matin*—and sometimes had pages in more modest publications and magazines, such as the *Revue Blanche*. His drawings for the press resembled caricatures. In this way, Lautrec was not only a keen observer of his time, but also immersed in his era. Now, more than a century later, he remains one of its great witnesses.

Henri Toulouse-Lautrec's glory, like his life, came with solitude and moments of distress, which, as we know, he drowned out with alcohol and women. No one continued where he left off, although Thadée Natanson declared himself to be Lautrec's "student," as did his friend Maurice Guibert. In fact, it is surely Picasso who best grasped the essence of Lautrec. His blue period owes much to the quick and expressive drawing of Lautrec's poster art. Picasso even pinned up a poster of May Milton in his Bateau Lavoir studio. If one really wants to name Lautrec's artistic heirs, Modigliani, Rouault, and even Van Dongen could claim that title.

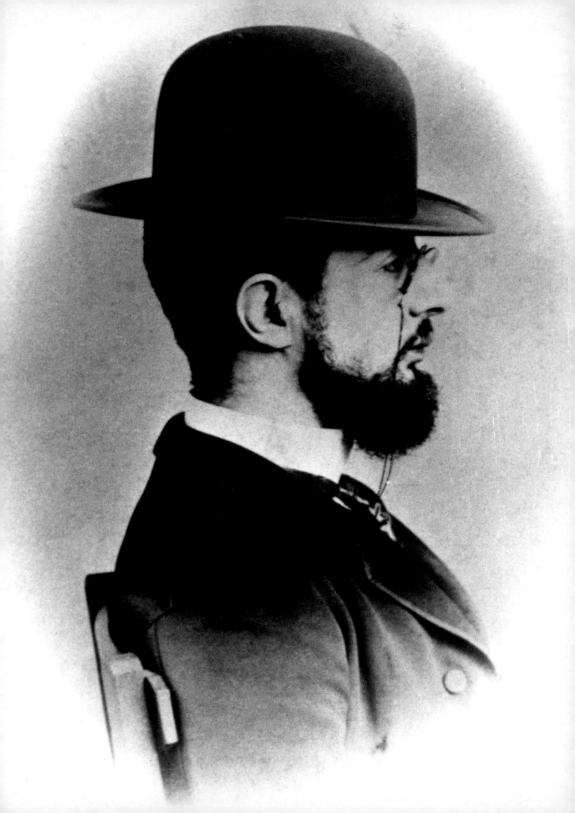

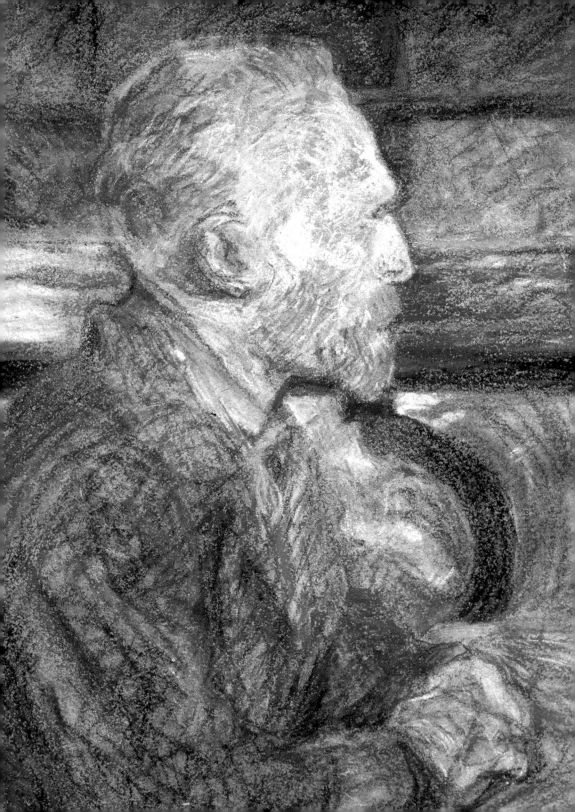

Mon cher Charles

Vous m'excuserez sûrement
de ne pas vous avoir
écrit plustôt quand vous d'ailleurs
saurez la cause de ce retard
Je suis tombé de sur
une chaise cassé
par terre et je me
suis cassé la cuisse gauche.

Henry de toulouse-lautrec

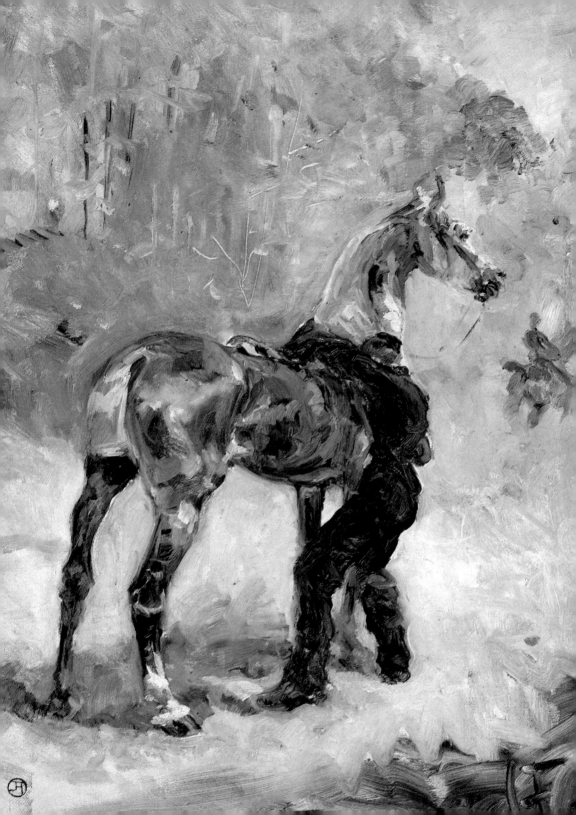

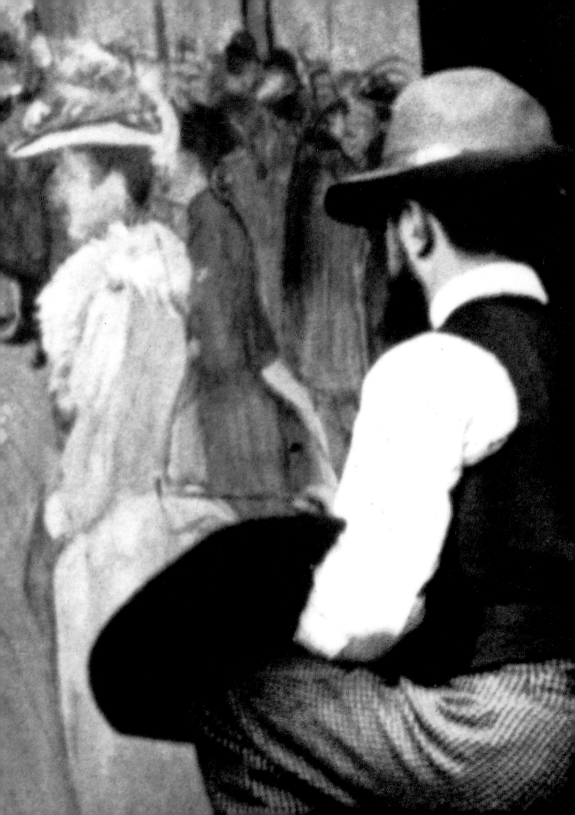

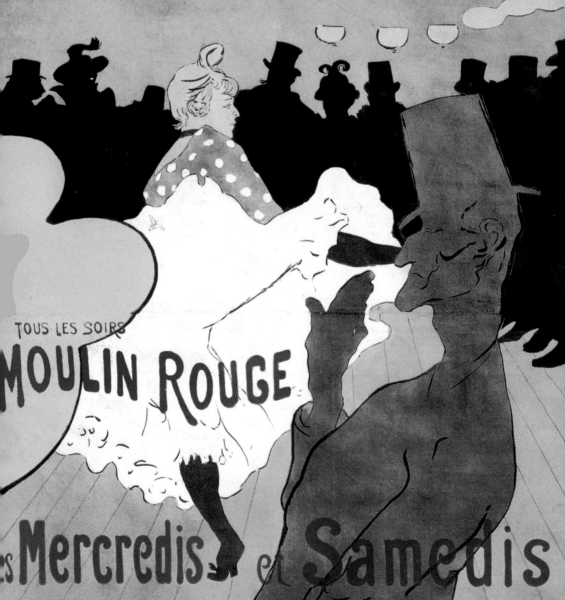

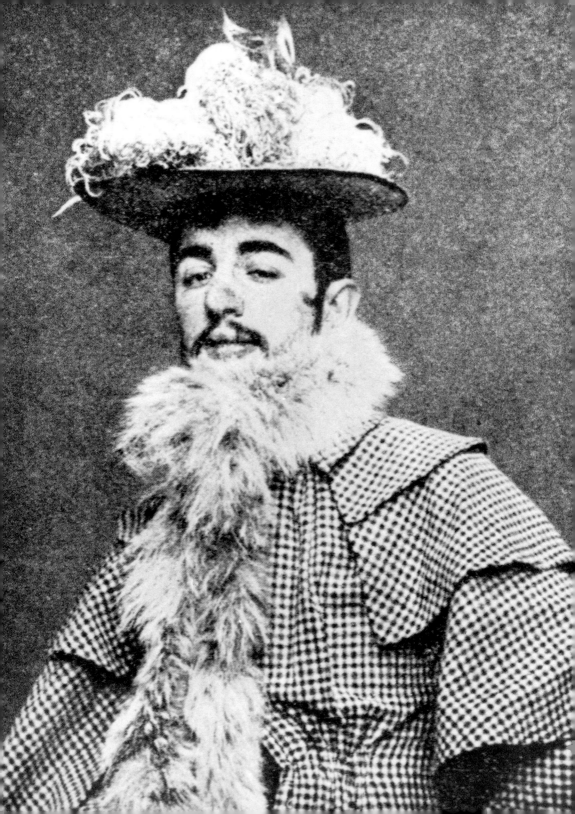

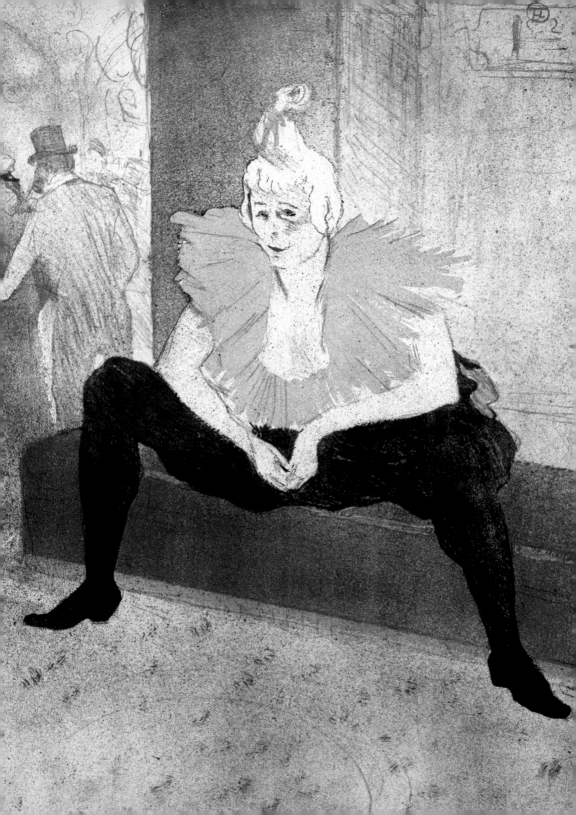

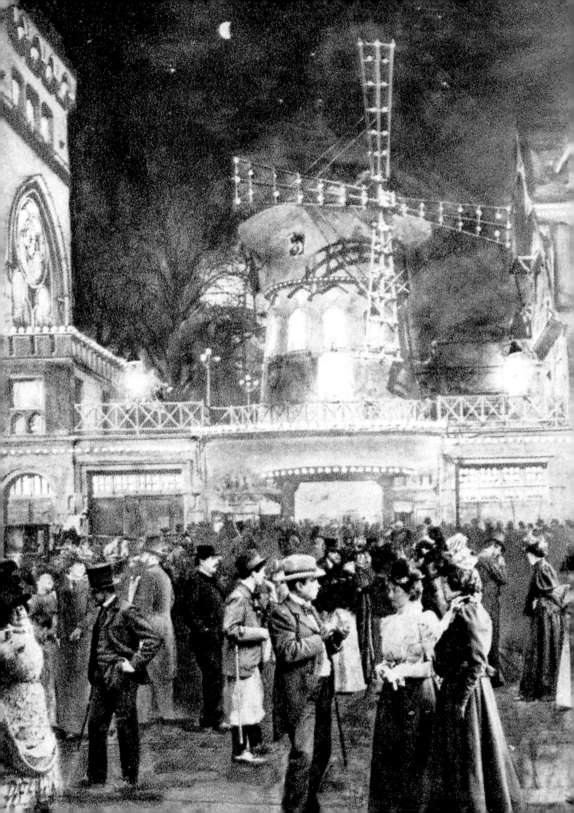

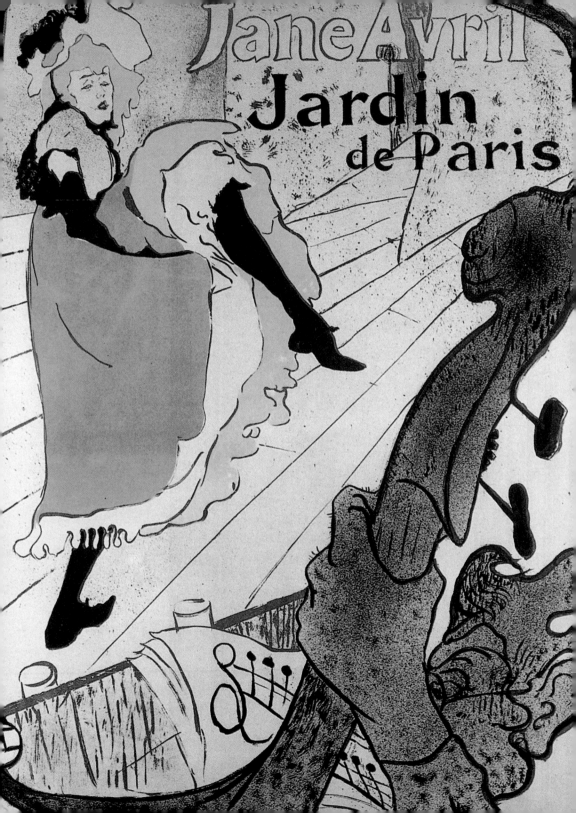

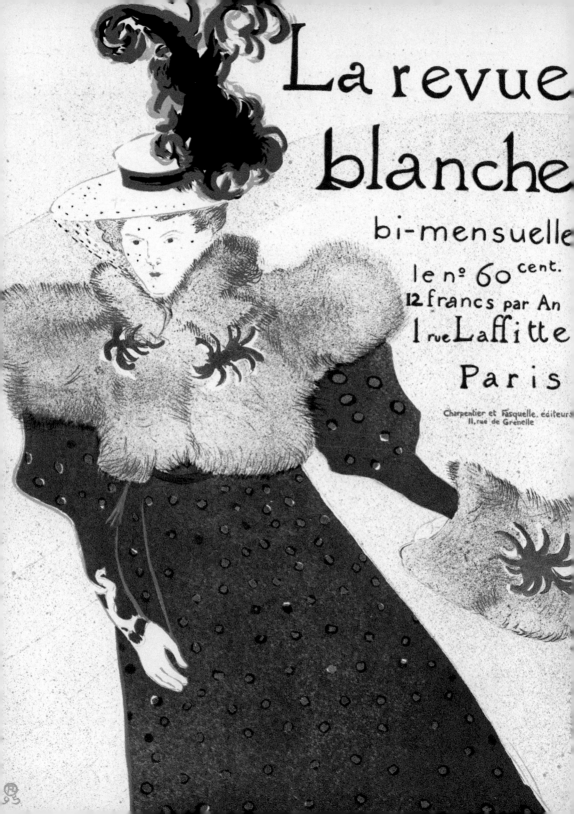

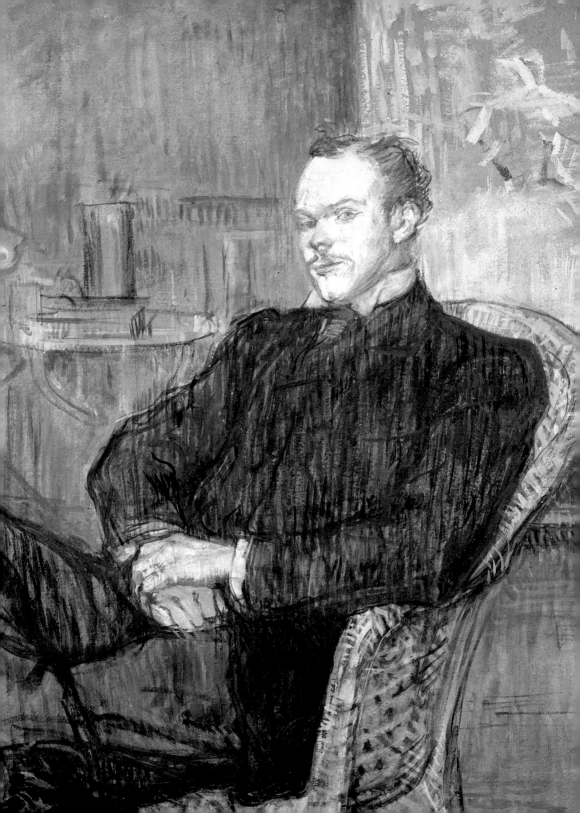

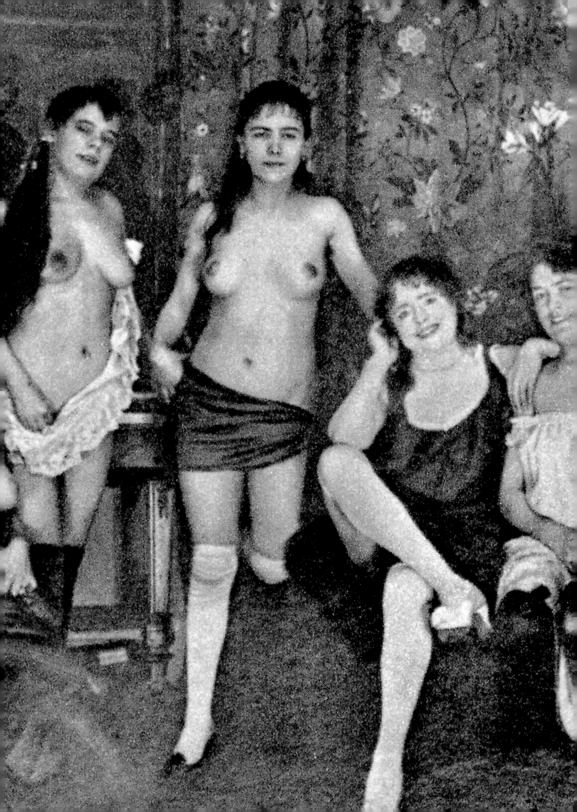

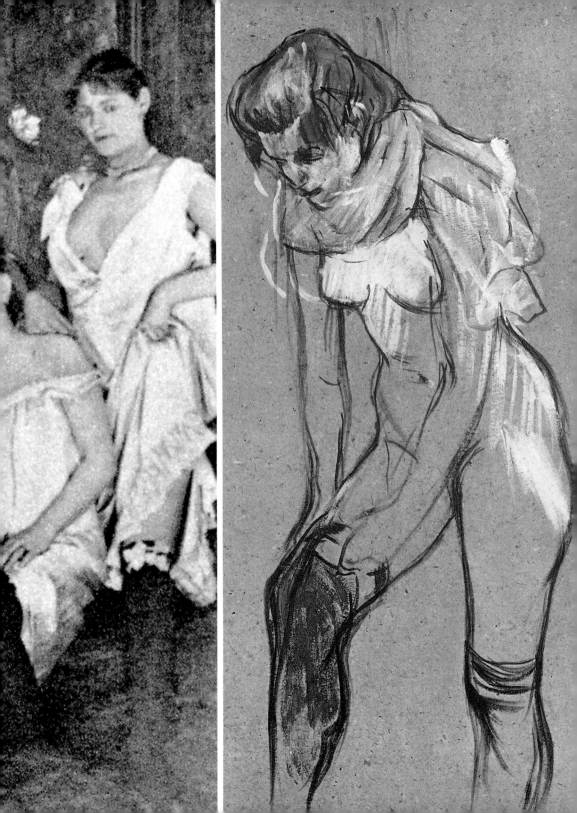

1889: Lautrec (left) as a choirboy.

Grenier, Nussez, and Lautrec
disguised as women.

The rue St-Vincent: a place that
comprised the myth of Montmartre
sung by Aristide Bruant
and Marc Ogéret in 1909.

Circa 1887:
Lautrec at a table at
the Moulin de la Galette.

The Chateau du Bosc.

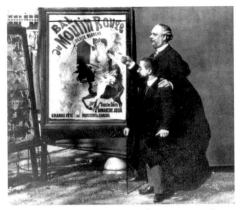

1892: Lautrec and Tremolada
(Zidler's assistant) in front
of the first Moulin Rouge poster.

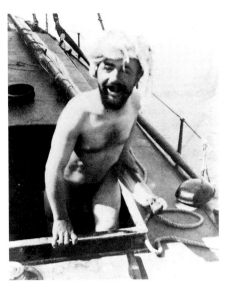

Circa 1899: Lautrec at Crotoy.

The Môme Fromage.

Margot, known
as Miss Rigolette.

The famous
Nini Patte-en-l'air.

Louise Weber, known
as La Goulue.

Lautrec by Guibert.

The sensual
Rayon d'or.

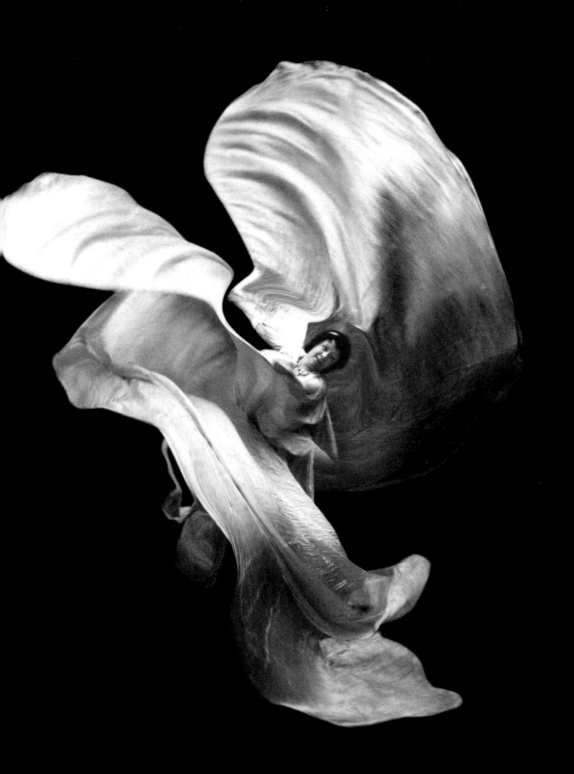

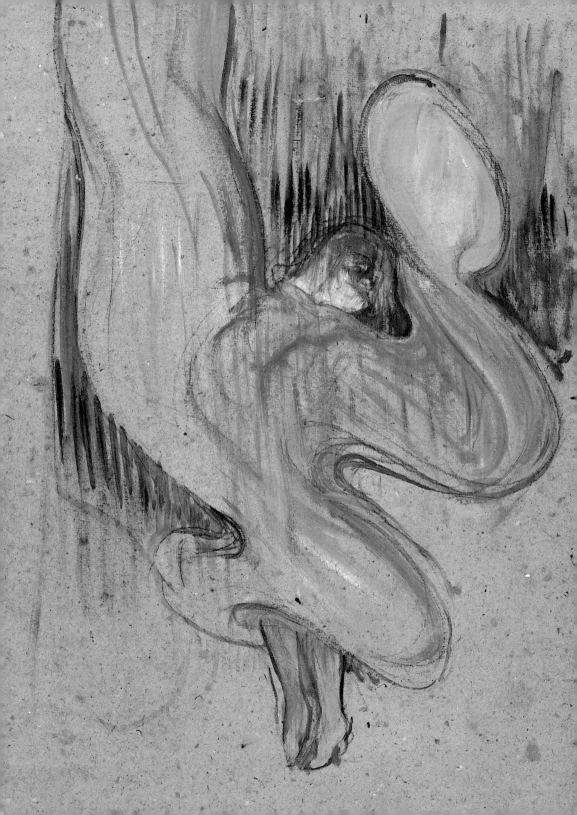

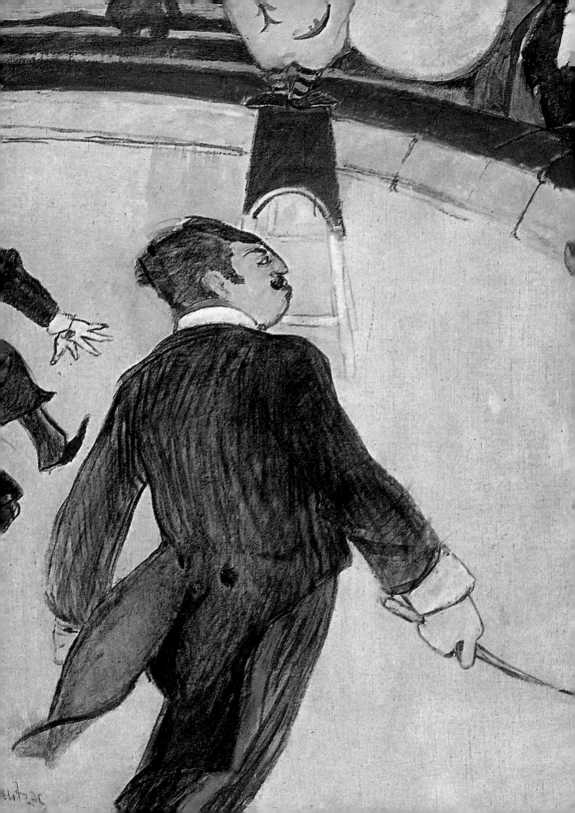

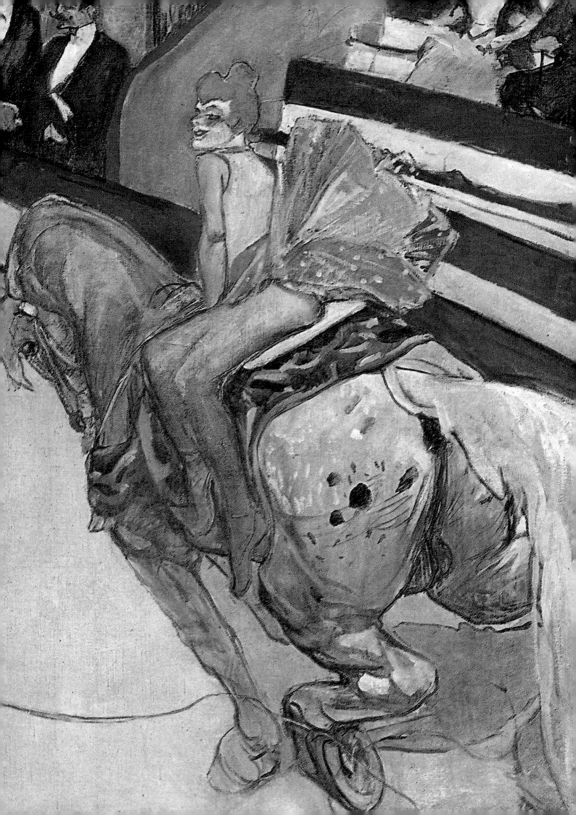

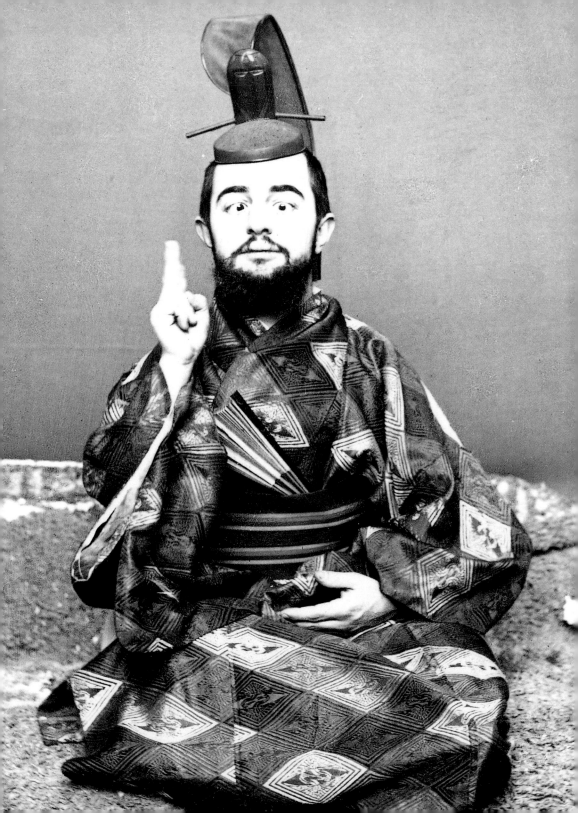

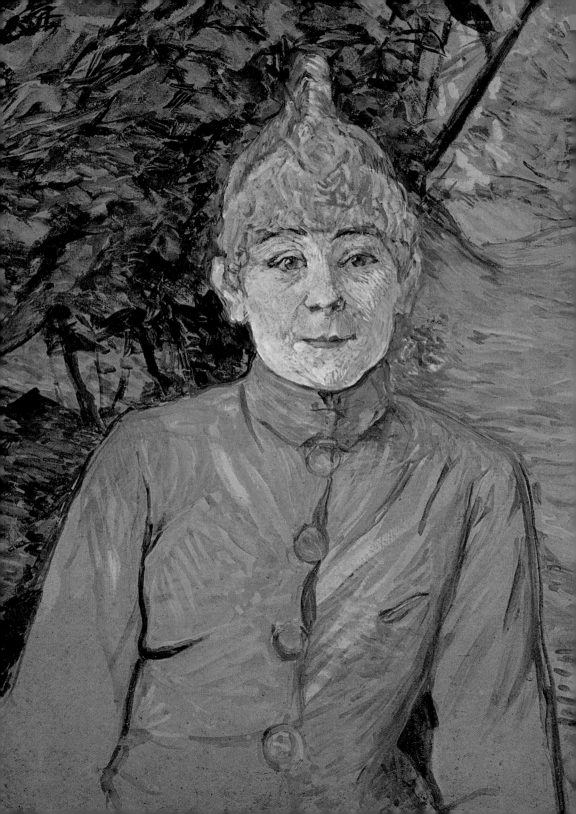

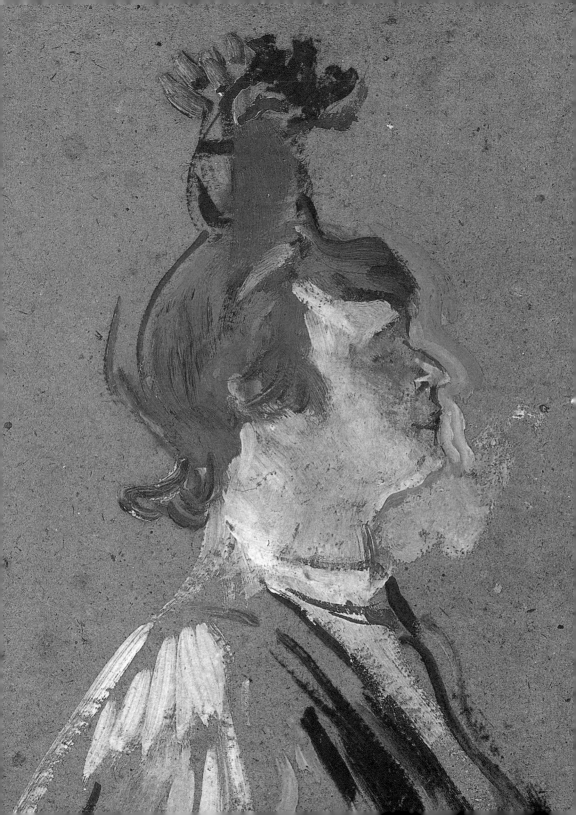

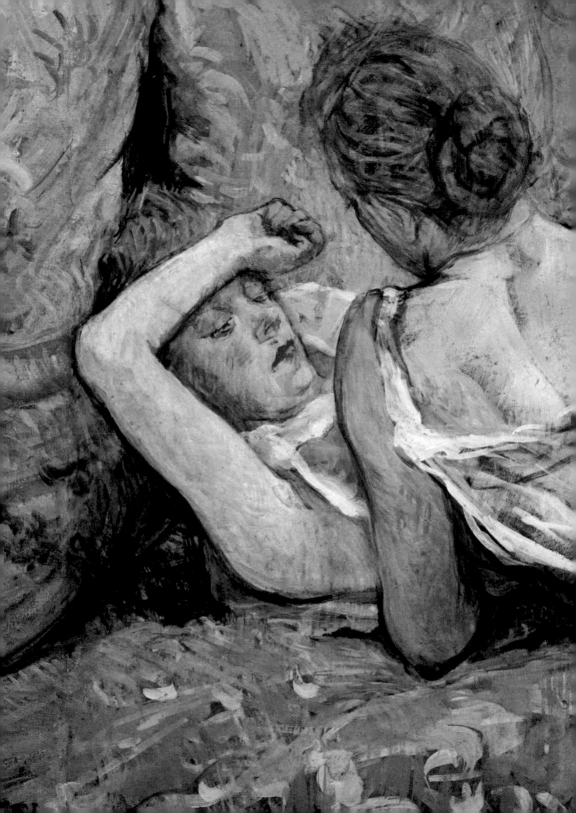

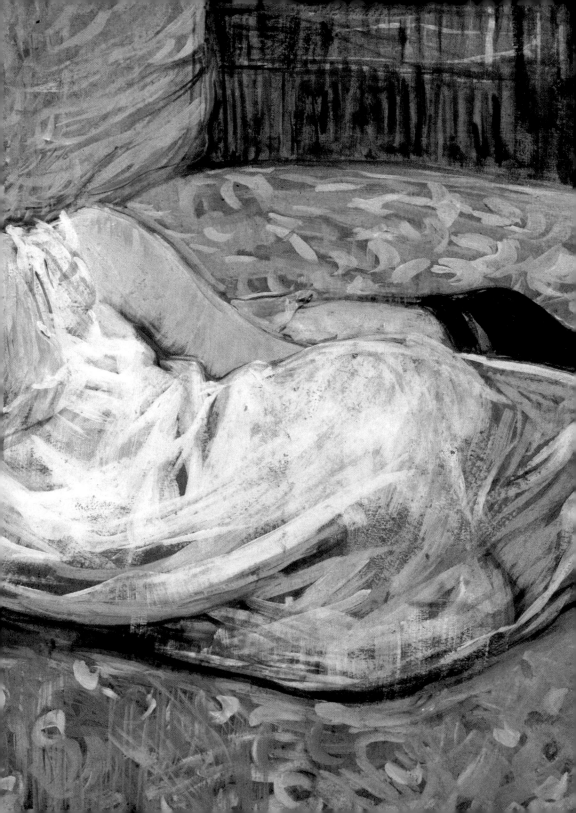

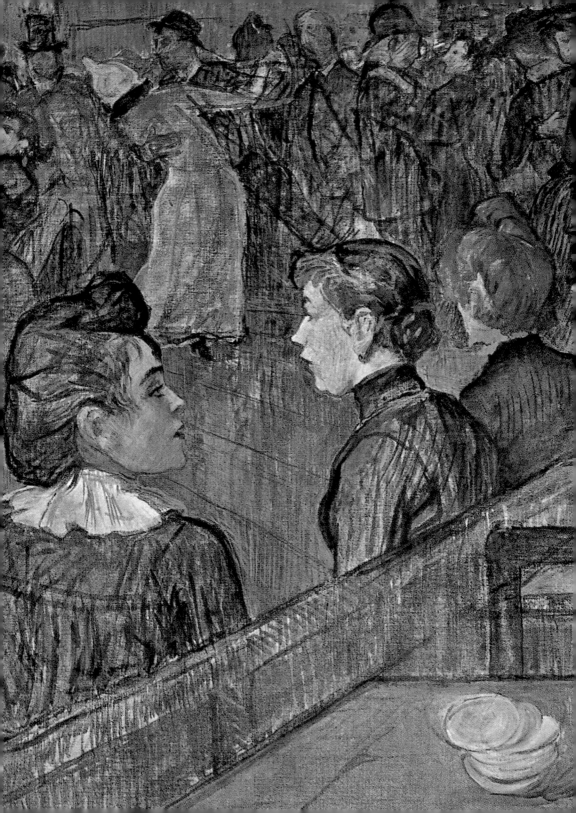

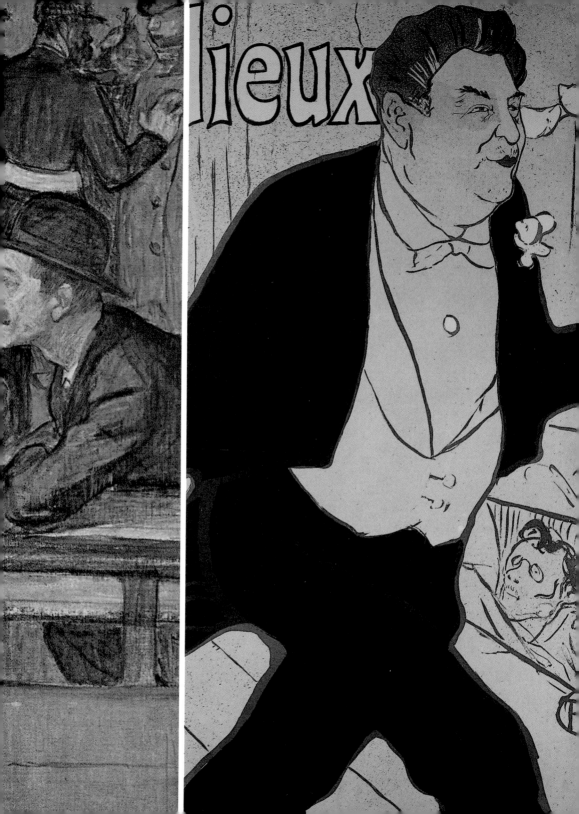

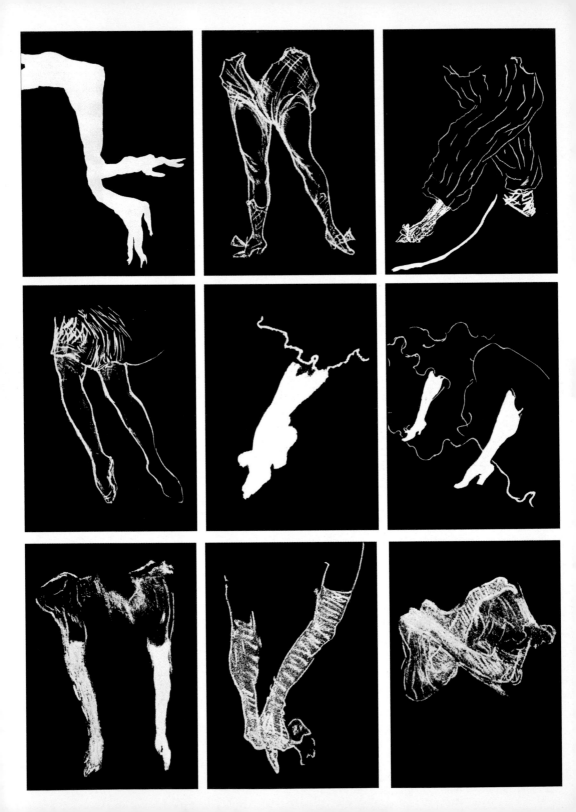

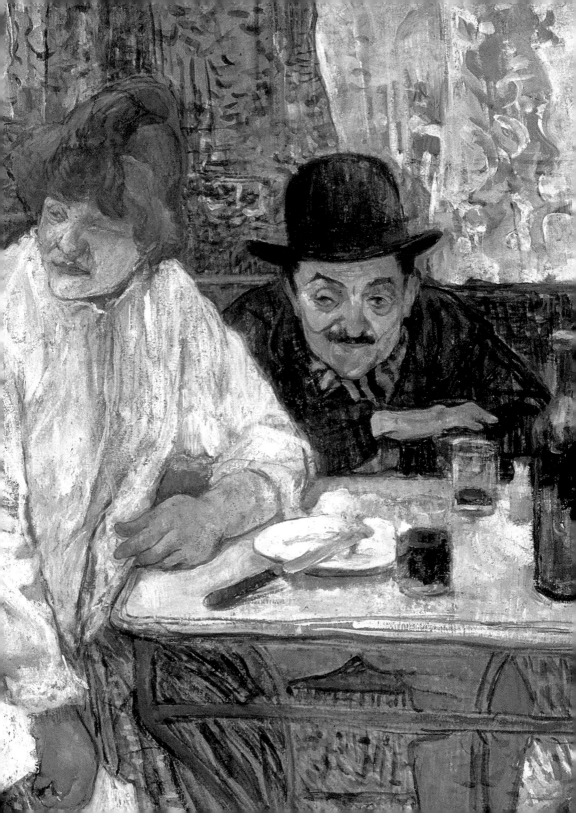

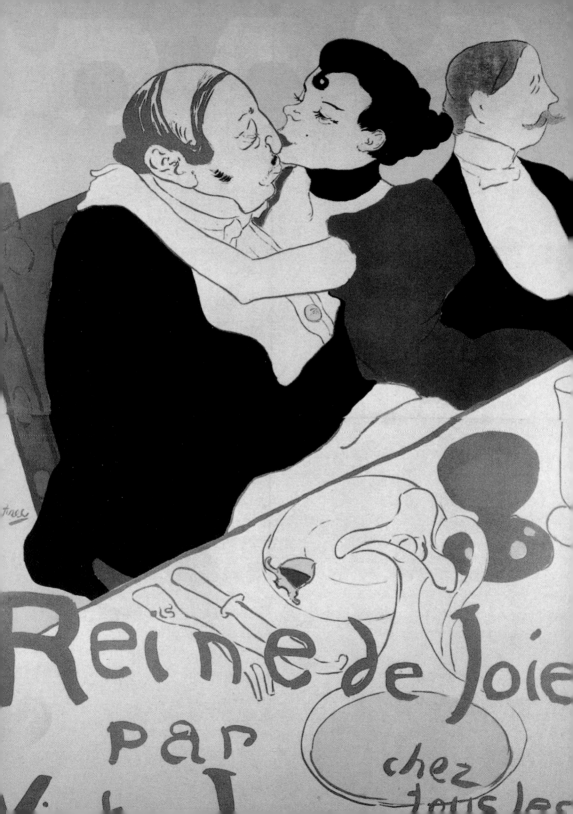

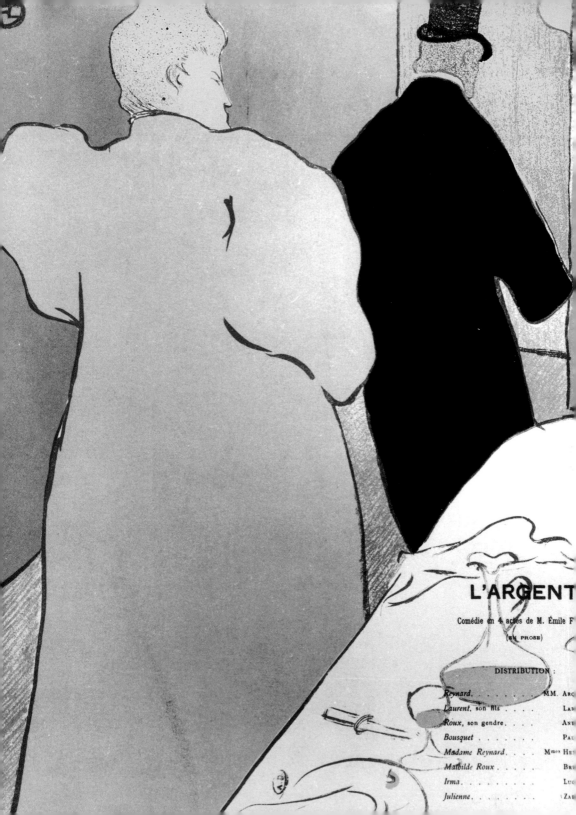

L'ARGENT

Comédie en 4 actes de M. Émile F

(EN PROSE)

DISTRIBUTION :

Reynard. MM. AR
Laurent, son fils LA
Roux, son gendre AN
Bousquet PAU
Madame Reynard. . . . Mmes HE
Mathilde Roux BR
Irma. LUC
Julienne. ZA

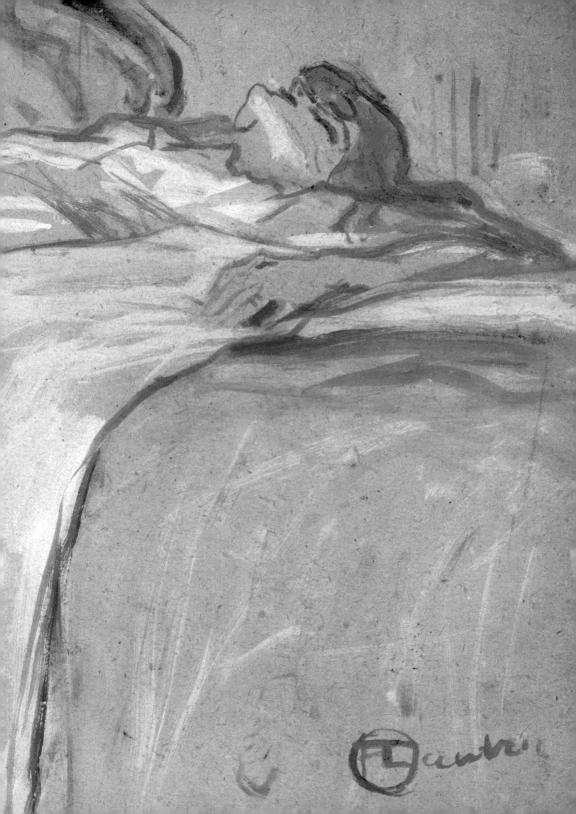

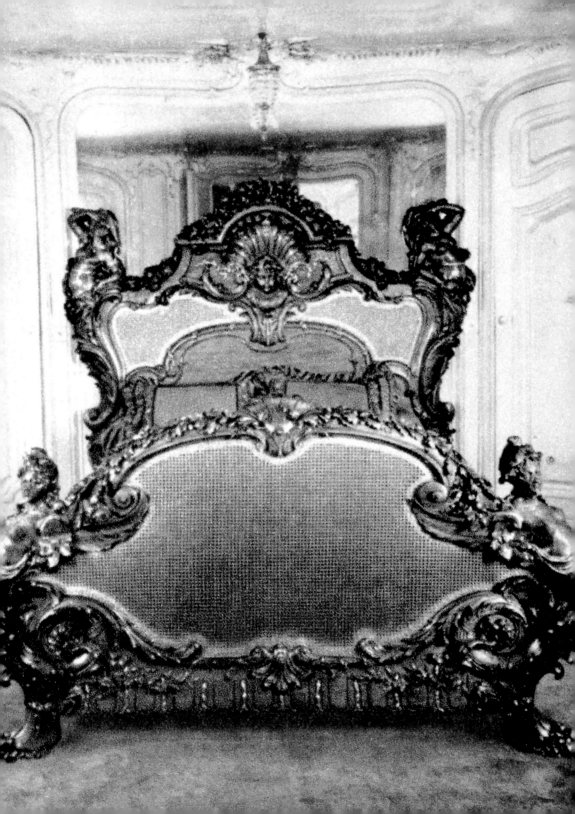

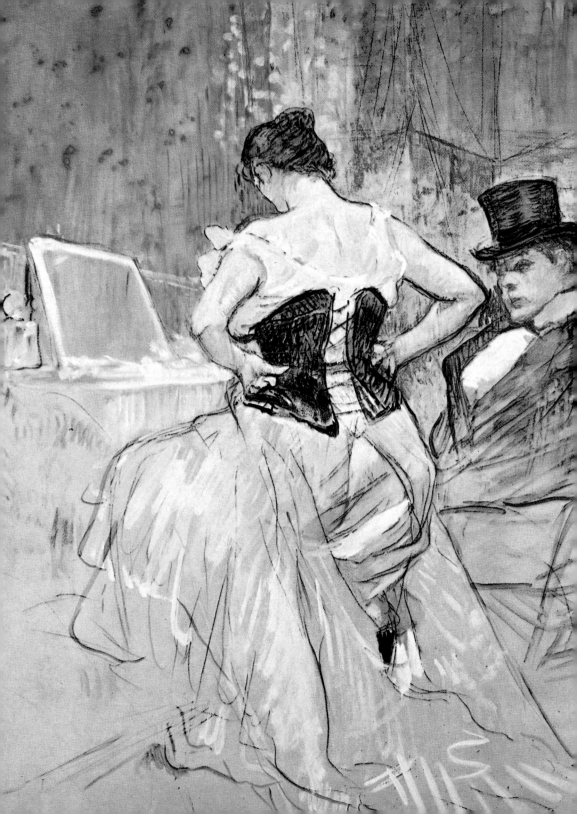

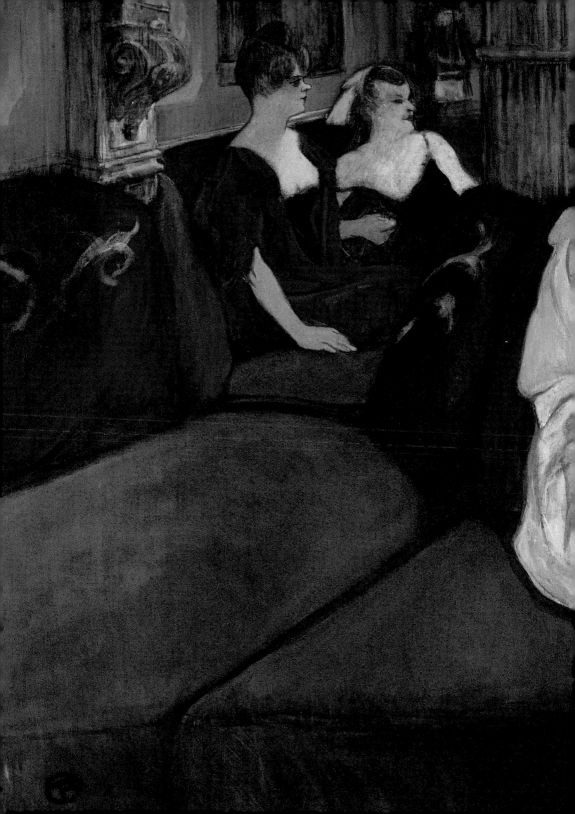

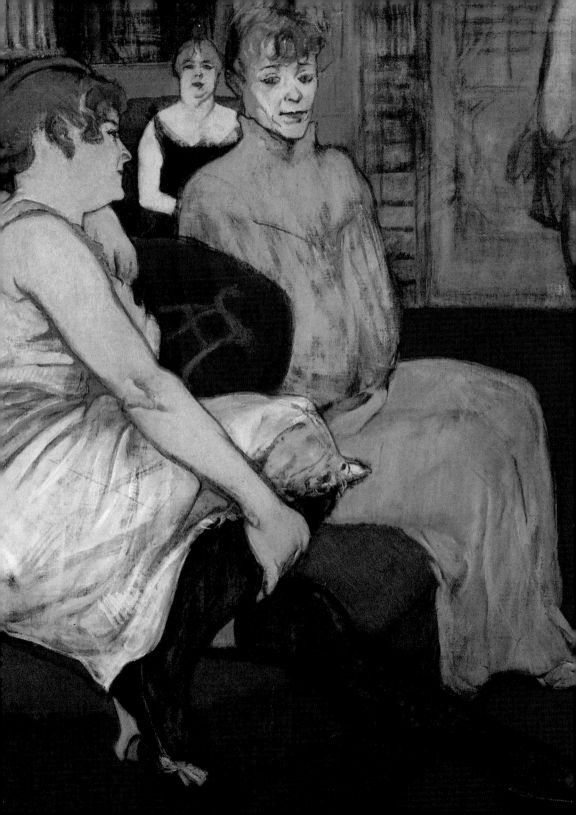

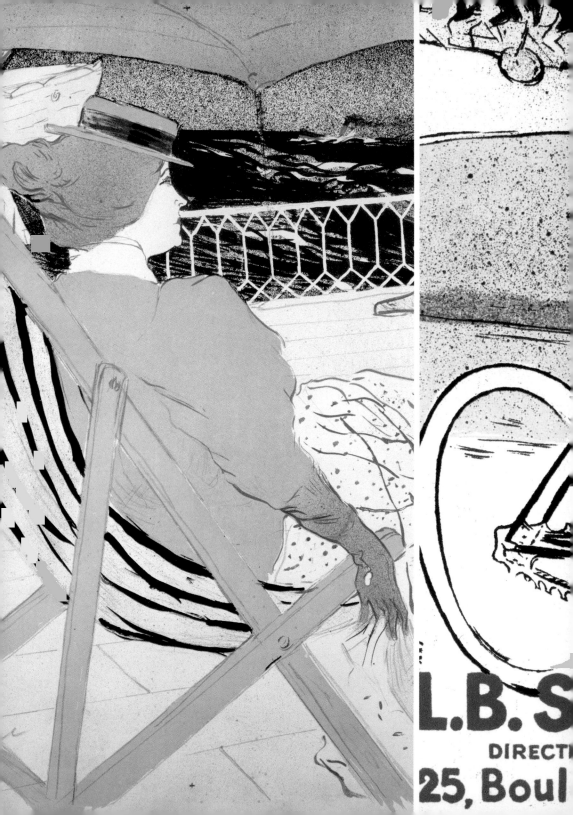

L.B.S

DIRECT

25, Boul

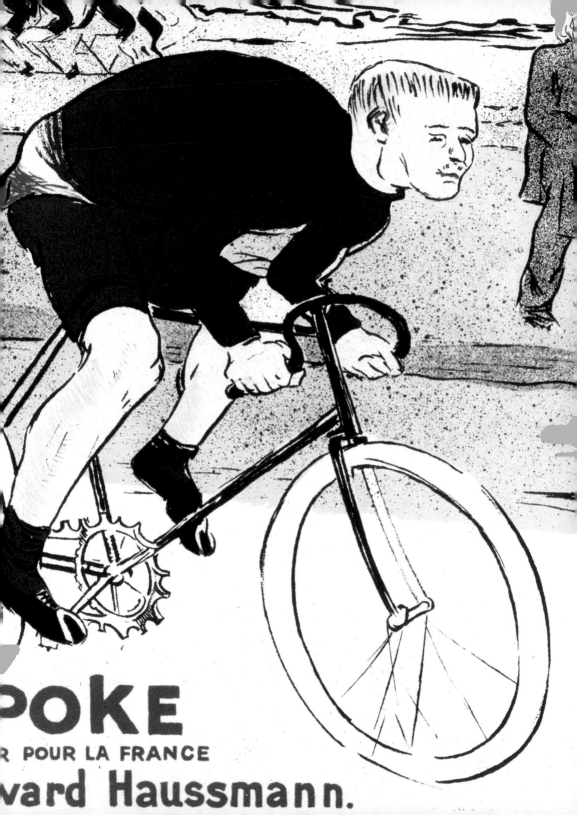

POKE

POUR LA FRANCE

vard Haussmann.

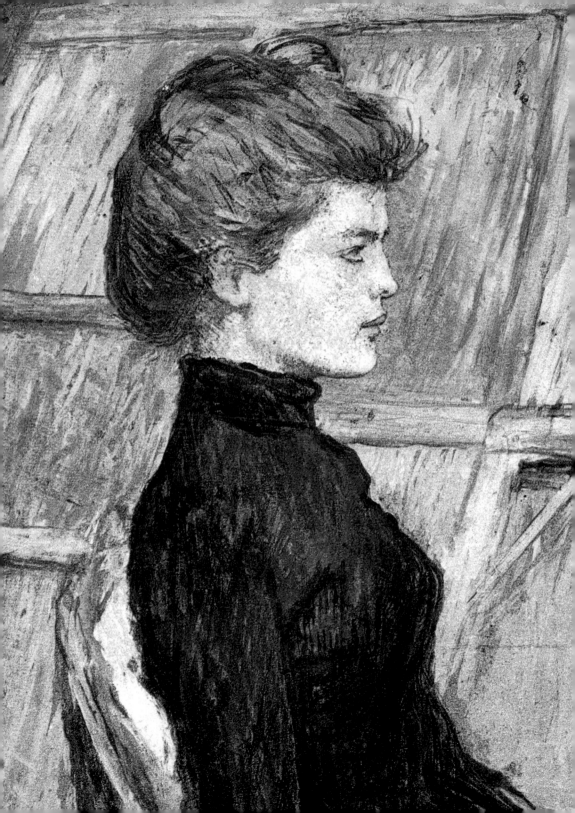

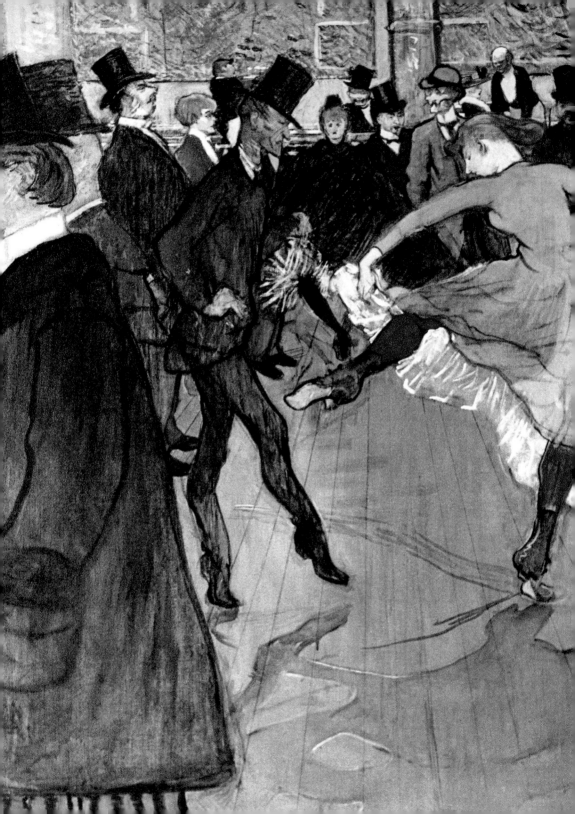

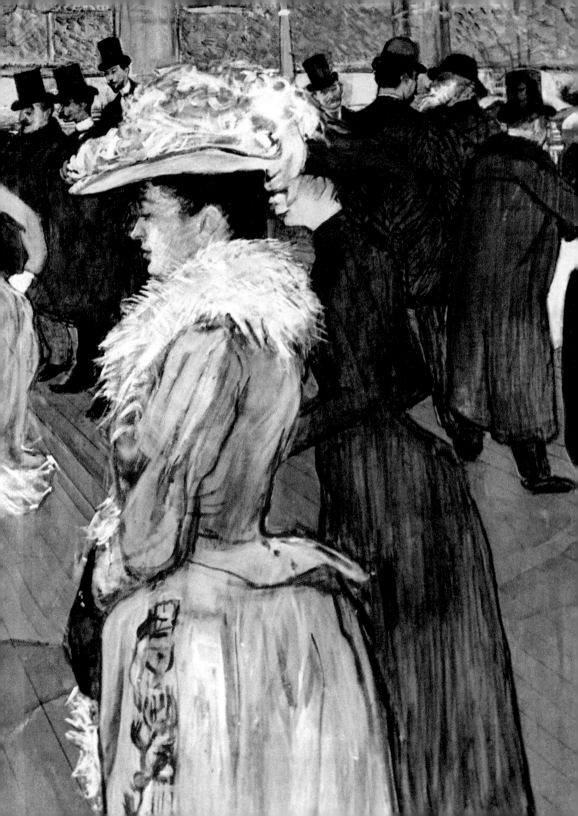

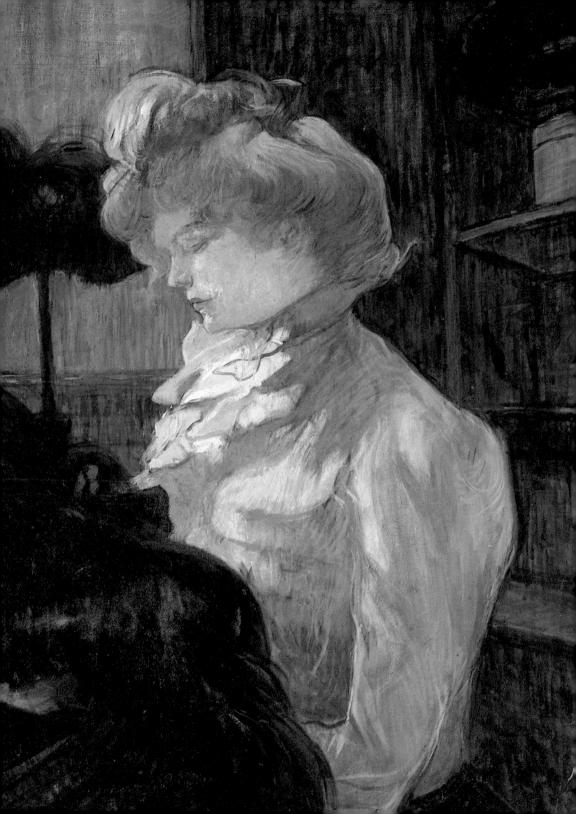

Chronology

1864: Henri Marie-Raymond de Toulouse-Lautrec-Montfa is born on November 24 in Albi, son of Count Alphonse de Toulouse-Lautrec and of Adèle Tapié de Céleyran.

1873: Raised on his family's Chateau du Bosc, in Céleyran, and in the Orléans region, he goes with his parents to Paris and enters the Lycée Fontanes.

1878: He breaks his left femur at the family's Chateau du Bosc in Albi.
He is sent to Amélie les bains and to Barèges for treatment, which is not successful.

1879: Accompanied by his mother in Barèges, he falls in a ditch and breaks his right femur. Bedridden, he begins to draw to amuse himself: portraits of friends and family, horses and other animals, and a first self-portrait.

1880: He continues to make charcoal portraits and academic drawings, such as scenes of labor in the fields.

1881: Upon receiving his baccalaureate in Toulouse, he decides to return to Paris to devote himself exclusively to painting.

1882: Student of René Princeteau, his father's friend, a painter of horses. Princeteau introduces him to Bonnat, who invites Lautrec to join his studio.

1883: Bonnat closes his studio. Henri de Toulouse-Lautrec joins the Cormon studio, where he meets such young painters as Louis Anquetin and Vincent Van Gogh.

1885: He moves in with Grenier, whom he met at the Cormon studio.

1886-1888: He lives in the heart of Montmartre, goes to the Bal du Moulin de la Galette, the Élysée Montmartre, the Divan Japonais, the Mirliton d'Aristide Bruant, and then the Moulin Rouge.
He completes the portrait of Vincent Van Gogh, numerous studies of women, and the famous *Moulin de la Galette.*

1889: He has his models pose in the garden of Père Forest. He becomes close friends with the painter François Gauzi, whom he met at the Cormon studio.
Théo Van Gogh buys a few paintings from him for the Goupil Gallery.
The Moulin Rouge is opened on October 5th by Joseph Oller and Zidler. They hang a Lautrec painting in the entrance, *The Circus Fernando, The Ringmaster.*

1890-1892: He goes twice to the exhibition group Les XX in Brussels, and then to London.
He has an exhibition at the Cercle Volney in April 1892, and at the Salon des Indépendants in June 1892.
Very productive, he continues to go to Montmartre and paints constantly. Large paintings of dances, studies of dancers and girls. He develops and asserts his own style.

1891: The year he becomes famous. At age 27, Henri de Toulouse-Lautrec becomes well-known because of his poster of the Moulin Rouge, commissioned by Zidler.
Between 1891 and 1894, he produces a series of thirty-one posters that revitalize this art form.

The Milliner, *1900, mixed media on wood, 24" x 19¹³",*
Musée Toulouse-Lautrec, Albi. © Musée Toulouse-Lautrec.

1892-1893: First lithographs, playbills for songs and theater programs, contributions to illustrated magazines, etc.

1894-1896: The great era of brothels. Henri de Toulouse-Lautrec draws the performers in the cafés and clubs, and the celebrities of Parisian high society.

1896: He spends the end of winter 1895-1896 in London, goes to Brussels, and discovers the masterpieces of the Flemish painters.
In the summer, he goes to Madrid, Toledo, and Lisbon. He develops color print work and completes the large series entitled *Elles*.

1897-1898: He moves into his new studio on Avenue Frochot and spends time in bars in the Pigalle neighborhood, such as Le Hanneton.
His show in London is a failure. Overworked, increasingly alcoholic, he has fits of violence.

1899: Illustrates Jules Renard's *Natural Histories*.
Between February and May, he is locked up at the clinic of Doctor Sémelaigne, in Neuilly. To prove to himself and his loved ones that he can still summon up his talents, he completes the series on the circus.
He spends the summer in Arcachon and does not return to Paris until winter.

1900: He visits the Exposition Universal, in Paris, in a wheelchair, settles in Bordeaux, and in June visits his mother in Malromé.

1901: His last winter in Bordeaux, then in Taussat.
He has a serious attack and is brought back to Malromé by his mother.
He goes back to Paris in May, puts his studio in order and signs his paintings. This would be his last trip.
He spends the months of July and August in Arcachon, then in Malromé, where he paints his last painting, *Admiral Viaud*.
He dies on September 9, after four nights of delirium. He is 37.

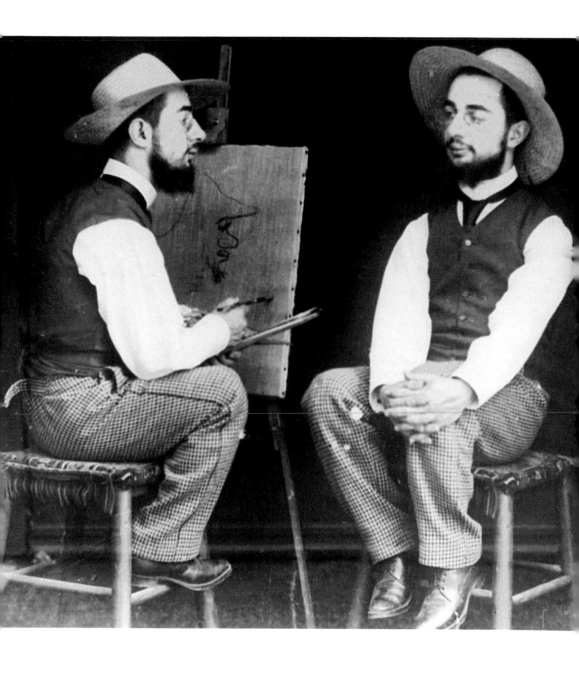

Toulouse-Lautrec in Paris

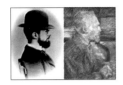

Lautrec at the age of 30, c. 1894, Musée Toulouse-Lautrec, Albi. © Musée Toulouse-Lautrec. *Portrait* by Vincent Van Gogh, 1887, pastel on cardboard, 22" x 18", Rijksmuseum Vincent Van Gogh, Amsterdam. At first sight, the asceticism of one man and the cheerful debauchery of the other would seem to set them apart. But in fact, the wounds suffered by these two vulnerable creatures establish a connection between them. This 1887 pastel borrows the Dutch's technique of energetic hatching and tonalities. Dying, Lautrec would say: "For me, he was a friend and insisted on demonstrating this to me." © AKG.

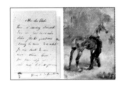

Letter from Lautrec to Charles Castelbon. Throughout his life, Lautrec wrote to his friends and relatives. The correspondence took place from the age of 6 years until seven weeks before his death and reveals his sense of humor, tenderness, love of life, and taste for refined pleasures, from gastronomy to esthetics. In this letter addressed to Charles Castelbon, he speaks of his first fall. © Musée Toulouse-Lautrec. *Artilleryman Saddling his Horse*, 1879, oil on canvas, 20" x 15", Musée Toulouse-Lautrec, Albi. The horse was one of the Lautrec's first subjects. His father previously drew horses. © Musée Toulouse-Lautrec.

The Englishman at the Moulin Rouge, 1892, lithograph, 10" x 7", Musée Toulouse-Lautrec, Albi. The Englishman William Tom Warrener studied in Paris at the Académie Julian. After becoming an impresario, he frequented nighttime cabarets, where he attempted to lure away the music hall artists. Lautrec often used him as a model. © Musée Toulouse-Lautrec.
Lautrec painting *Dance at the Moulin Rouge* in 1890. Lautrec painted quickly from live subjects or in his studio. Most of his works have a feeling of being left unfinished, which reinforces their modernity today. © Musée Toulouse-Lautrec.

Le Caveau du Chat Noir. Rodolphe Salis's cabaret at the Chat Noir was one of the most important sites in late 19th century Montmartre. Lautrec would spend a portion of his evenings there, surrounded by poets and artists. © All rights reserved.
Aristide Bruant in his Cabaret, 1890, lithograph, 52" x 38", Musée des Arts Décoratifs, Paris. A popular and anti-conformist singer, Bruant used to roar his laments, hands in pockets. His rough wit and riotous voice fascinated Lautrec. From that time on, Lautrec's lithographic portraits seemed emblematic of Montmartre's glorious and bygone days. © AKG.

Moulin Rouge, La Goulue and Valentin le Désossé, 1891, lithograph in four colors, 33" x 48", Musée Toulouse-Lautrec, Albi. The nickname "La Goulue," a pseudonym for Louise Weber, came from the singer and comedienne's insatiable appetite. This poster, where Valentin le Désossé appears in the foreground, made the painter famous at the age of 27. © Musée Toulouse-Lautrec.
Lautrec disguised as a Belle Époque woman, c. 1892, Musée Toulouse-Lautrec, Albi. Lautrec loved to cross-dress, and Maurice Guibert, a photographer and friend of the painter, became Lautrec's accomplice in this eccentric behavior. © Musée Toulouse-Lautrec.

Grille d'égout [Sewer Grating] and La Goulue at the Moulin Rouge. Grille d'égout, called by this nickname due to the gap between her teeth, and La Goulue enlivened the Moulin Rouge, twirling the lace of their petticoats during the famous quadrille. © René Dazy/Rue des Archives.
Seated Clown (Miss Cha-U-Kao), 1896, lithograph, 20" x 16", Queensland Art Gallery, Brisbane (Australia). She was unequaled in the way she pranced about on her performing horse, dressed in black trousers with ribbon tassels in her hair. This female clown and acrobat owed her nickname to a distortion of a frenzied dance of the time: the "chahut-chaos." © Bridgeman.

The Moulin Rouge, one of the pilgrimage sites for foreign tourists. Lautrec conferred respectability on this famous dance hall where the quadrille triumphed. © All rights reserved.
Jane Avril at the Jardin de Paris, 1893, lithograph, 21" x 16", Musée Toulouse-Lautrec, Albi. The dancers of the time were characters who cultivated a certain vulgarity. But Jane Avril, one of the most distinguished and one of Lautrec's famous models, befriended him, as she did Alphonse Allais. © Musée Toulouse-Lautrec.

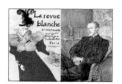

La Revue blanche, 1895, poster, 51" x 37", Musée Toulouse-Lautrec, Albi. Lautrec had used Misia as a model. She was the wife of Thadée Natanson, co-director with his brother Alexandre of this literary and artistic revue, which was very fashionable in the late 19th century. The couple appreciated Lautrec's nonconformity and humor. © Musée Toulouse-Lautrec. *Paul Leclercq*, 1897, oil on cardboard, 21" x 26", Musée d'Orsay, Paris. In his memoirs, *Autour de Lautrec* (1921), Paul Leclercq, cofounder of *La Revue blanche*, tells how he returned twenty or so times to the studio on the rue Frochot, but spent a total of only four hours there. © Giraudon/Bridgeman.

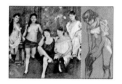

Les Demoiselles de la Rue des Moulins. Lautrec liked to take refuge in the brothels along the rue Moulins, and this very famous one was of the most luxurious in Paris. Inside the brothels, he felt safe from people's foolish remarks and from all sorts of dangers that he experienced in 1894. Faced with his deformity, the young women showed themselves to be unconcerned and even understanding. © All rights reserved. *Woman Pulling Up her Stocking*, 1894, pastel on card-board, 24" x 18", Musée Toulouse-Lautrec, Albi. When the artist painted prostitutes, he did so with brotherly feeling. © Musée Toulouse-Lautrec.

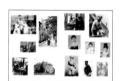

Left: Lautrec as a choirboy (1889). © Musée Toulouse-Lautrec; Rue St-Vincent. © All rights reserved; Grenier, Nussez, and Lautrec disguised as women. © All rights reserved; Lautrec at a table at the Moulin de la Galette (c. 1897). © Musée Toulouse-Lautrec; the Chateau du Bosc. © All rights reserved; right: Lautrec and Tremolada (Zidler's assistant) in front of the first Moulin Rouge poster (1892). © Musée Toulouse-Lautrec; Lautrec at Crotoy (c. 1899). © Musée Toulouse-Lautrec; the Môme Fromage. © All rights reserved; Margot, known as Miss Rigolette. © All rights reserved; the famous Nini Patte-en-l'air. © All rights reserved; Louise Weber, known as La Goulue. © AKG; Lautrec by Guibert. © All rights reserved; the sensual Rayon d'or. © All rights reserved.

Miss Loïe Fuller or "the triumph of electricity." A phenomenon: at the age of 5, this American artist sang in public and accompanied herself on the piano; at 13, she gave a lecture; at 18, she performed Shakespeare and then, in Paris, invented a curious dance where she was enveloped in veils beneath projected lights. © Roger-Viollet Collection. *Loïe Fuller at the Folies Bergères*, 1893, black chalk and oil on cardboard, 25" x 18", Musée Toulouse-Lautrec, Albi. This specta-cle fascinated Lautrec, who was enthusiastic about all the effects of electricity and its illusions. But Loïe Fuller ignored the painter and never wanted to meet him. © Musée Toulouse-Lautrec.

Lautrec in his studio with Misia Natanson, private collection. Misia, née Godebska, a seductress of Polish heritage, served as Lautrec's model on repeated occasions. With her first husband, the publisher and patron Thadée Natanson, she entertained numerous artists. They were at the center of a brilliant circle, mostly because of the *Revue blanche*, established to defend Captain Dreyfus. © Charmet/Bridgeman Archives. *Portrait of Misia Nathanson* (detail), 1895, charcoal with watercolor on paper, 58" x 41", Musée Toulouse-Lautrec, Albi. Misia was Lautrec's friend and passionate admirer. © AKG.

At the Circus Fernando: the Ringmaster, 1887-1888, oil on canvas, 41" x 64", Art Institute, Chicago. The Circus Fernando had been set up along the boulevard Rochechouart. It became a theater in 1894, but was frequented by Degas, Renoir, and Lautrec, who had a passion for horses and circuses. This work is his first large pictorial treatment of the subject. Undoubtedly influenced by Japanese art, he simplifies the lines, reduces his palette, and distorts the laws of conventional perspective. © Bridgeman.

The Japanese Sofa, 1892, lithograph in four colors, 31" x 23", Musée Toulouse-Lautrec, Albi. It was at the Jardin de Paris (a cabaret on the Champs-Élysées) and at the Folies Bergères that Jane Avril, daughter of an unmarried woman who died insane and an Italian aristocrat, met with her greatest success. She herself suffered from serious nervous disorders. The painter knew that this "pale, slender, and graceful, but never sad" young woman appreciated his work. © Musée Toulouse-Lautrec. **Lautrec disguised as a samurai**, 1892. Lautrec once again displayed his penchant for dressing in disguise and his fondness for Japan. © Musée Toulouse-Lautrec.

Lautrec, center, seems to be accompanied by his father, Alphonse (to the right with a falcon) and René Princeteau, **on the family estate in Bosc**, where he spent his childhood. A year earlier, at the age of 14, Lautrec had fractured his left leg while climbing onto a low chair in one of the living rooms. His capricious father spent his days riding and hunting, whereas the painter (Princeteau) soon noticed young Henri's gifts and gave him his first drawing lessons. © Musée Toulouse-Lautrec.

The Streetwalker, c. 1890 -1891, oil on cardboard, 26" x 21", private collection. Portrait of a woman, probably the dancer Louise Weber, known as La Goulue. © Peter Willi/Bridgeman.
La Goulue's Head (detail), c. 1895, gouache on cardboard, 16" x 12". Refined and elegant strokes allow for an economy of color: Lautrec gets to the essentials. His works can seem like mere sketches. They are the result of a desire to understand and instantly capture an expression or attitude. © All rights reserved.

Two Friends, 1895, oil on cardboard, 18" x 27", private collection. Tact and delicacy were employed to suggest a situation that, at the time, seemed shocking. All the subtlety of Lautrec's genius is seen in this type of scene, where the artist's pencil catches an intimacy. He excels in this and is never vulgar but full of humanity and shared love. His stroke evokes the finest draftsmen of the 18th century. © Bridgeman.

At the Moulin de la Galette, 1889, oil on canvas, 40" x 35", Art Institute of Chicago. Located on the hill of Montmartre, on the site of an ancient windmill, the Moulin de la Galette was a public dancehall, made famous by the painters of the 1870s. In 1876, Renoir made it the subject of one of his masterpieces. © All rights reserved. *Caudieux*, 1893, lithograph in four colors, 51" x 37", Musée Toulouse-Lautrec, Albi. Nicknamed The Cannon Man because of his surprising suppleness and his stomach, which was as round as a cannonball, Caudieux enjoyed a certain notoriety around 1893, after having been a comic singer. © Musée Toulouse-Lautrec.

Patchwork of Legs and Arms. Lautrec, who met Guilbert in 1893, never ceased sketching her from every angle. In this variation, the artist emphasizes the movement of her seemingly endless arms and legs. © All rights reserved. **Yvette Guilbert Singing "Linger Longer Loo"**, 1894, gouache on cardboard, 23" x 17", Pushkin Museum, Moscow. Slender, even boney, her arms hidden in long black gloves that reached up above her elbows, Yvette Guilbert—the "Sarah Bernhardt des fortifs," an unrivaled fortune-teller as well as singer of the poetry of Richepin and Bruant—was Lautrec's favorite model. © AKG.

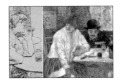

The Drinker, 1889, oil on canvas, 19" x 25", Musée Toulouse-Lautrec, Albi. An elderly trapeze artist who had suffered an accident, Suzanne Valadon posed for such painters as Puvis de Chavannes and Renoir. She also modeled for Lautrec and became his mistress. She sought to become his wife, but he chose to abandon her after recognizing her artistic talent. © Musée Toulouse-Lautrec. *À la Mie*, 1891, watercolor and gouache on paper, mounted on canvas, 21" x 27", collection S. A. Denis, Museum of Fine Arts, Boston (United States). To the right, one can recognize Maurice Guibert, a painter, bon vivant, photographer, and friend of Lautrec. © AKG.

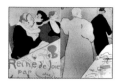

Reine de joie [Queen of Joy], 1892, lithograph in four colors, 54" x 37", Musée Toulouse-Lautrec, Albi. Poster commissioned by Polish writer Victor Joze, who was Lautrec's friend and neighbor. This would be used again for the cover of his novel, *Reine de joie - Mœurs du demi-monde*. © Musée Toulouse-Lautrec. Photograph of **A Gentleman and a Lady**, 1895, lithograph, 16" x 20", poster for the play at the Théâtre Libre, *L'Argent*, Bibliothèque des Arts Décoratifs, Paris. This sums up the art of Lautrec's poster work: an intense effect with a simple composition. Everything is said through a scene, an attitude, or a movement. © Charmet/Bridgeman Archives.

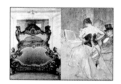

Alone, 1896, oil on board, 12" x 16", Musée d'Orsay, Paris. Study for the famous series, *Elles*. Here again, in a few strokes, Lautrec is able to depict the state of abandon and fatigue of the woman, who could be an exhausted dancer after a performance or a prostitute between two customers. Alone, the woman recovers her spirit and rests before her next client. © Jean Schormans/RMN.

One of the fabulous and sumptuous beds from 24 rue des Moulins. Each room had a specific style. This one, in heightened Louis XIV taste, is one of the most beautiful examples. François Gauzi, a painter and student of Cormon, as well as a great friend of Lautrec, took this photograph. © All rights reserved.
Woman in a Corset, 1896, oil and chalk on canvas, 41" x 26", Musée des Augustins, Toulouse. Officially residing on the rue des Moulins, Lautrec painted the entire household: lodgers, the launderer, the landlady, and even the dog. © All rights reserved.

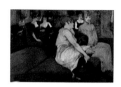

At the Salon on the Rue des Moulins, 1894, oil on canvas, 43" x 47", Musée Toulouse-Lautrec, Albi. The largest picture created by Lautrec on the subject, this oriental salon on the rue des Moulins translates the overheated ambience and atmosphere of the shuttered house without any mannerism. The harmonies of pink, mauves, and poisonous tones thoroughly evoke the idea of confinement. Without compassion or sentimentality, he shows the shutters just as they are, yet a classical grandeur is conveyed and this canvas radiates a certain sadness. © Musée Toulouse-Lautrec.

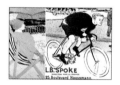

The Passenger in Cabin 54 – On a Cruise, 1895, lithograph in six colors, 23" x 16", Staatliches Kupferstichkabinett, Dresden. Guibert offered Lautrec a seat on the steamer Le Chili to visit Bordeaux, Lisbon, Madrid, and Toledo. He fell in love with a beautiful passenger, whose indifference resulted in his early return to France. © AKG.
The Simpson Chain, 1896, lithograph in four colors, 35" x 49", private collection, Paris. Thanks to Tristan Bernard, director of the Buffalo velodrome, Lautrec gained access to the world of sport. He designed this poster, among others, for Simpson bicycle chains. © AKG.

Juliette Vary, 1888, gouache on cardboard, 30" x 20", Kunsthalle, Bremen. Juliette Vary was Lautrec's neighbor in Paris. He had known her as a child and became reacquainted with her in Paris. He was struck with admiration for her wild beauty, her elegance, her appearance, and the purity of her features. © AKG.
Juliette Vary in 1888. She was 17 years old when she had herself photographed and posed for him. Her lovely face can be seen in a number of his pictures. © All rights reserved.

Training of the New Girls by Valentin le Désossé, c. 1889 -1890, oil on canvas, 45" x 59", Museum of Art, Philadelphia. Valentin le Désossé was an important personality in Lautrec's universe, all the more so because the latter had scant interest in male characters. Being tall and a skilled dancer, he was in some ways the opposite of Lautrec. This son of a notary (his real name was Edmé Étienne Renaudin) was a wine merchant and then a debt collector before becoming a ballet master. At the Élysée-Montmartre, as at the Moulin Rouge, he was the irreplaceable and legendary partner of La Goulue. © All rights reserved.